Adult Coloring Book
Stress Relief
Wildlife Animal Designs,
Mandalas, Patterns

Adult Coloring Book: Stress Relief Wildlife Animal Designs, Mandalas, Patterns

Copyright © 2017 Hayley Potts All Rights Reserved

ISBN: 978-1544774015

Images may not be copied, printed or otherwise disseminated without express permission of Hayley Potts or her agents.

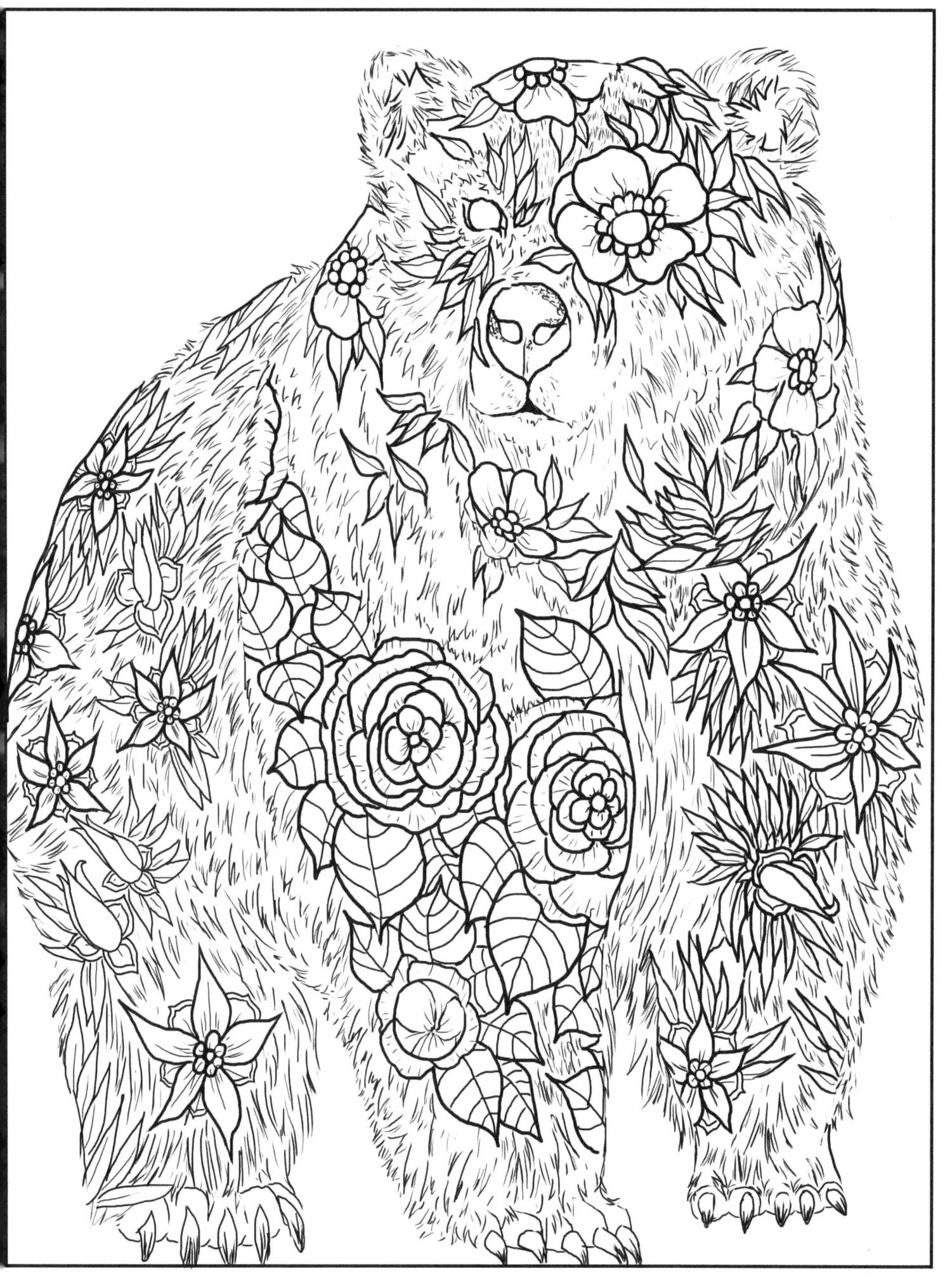

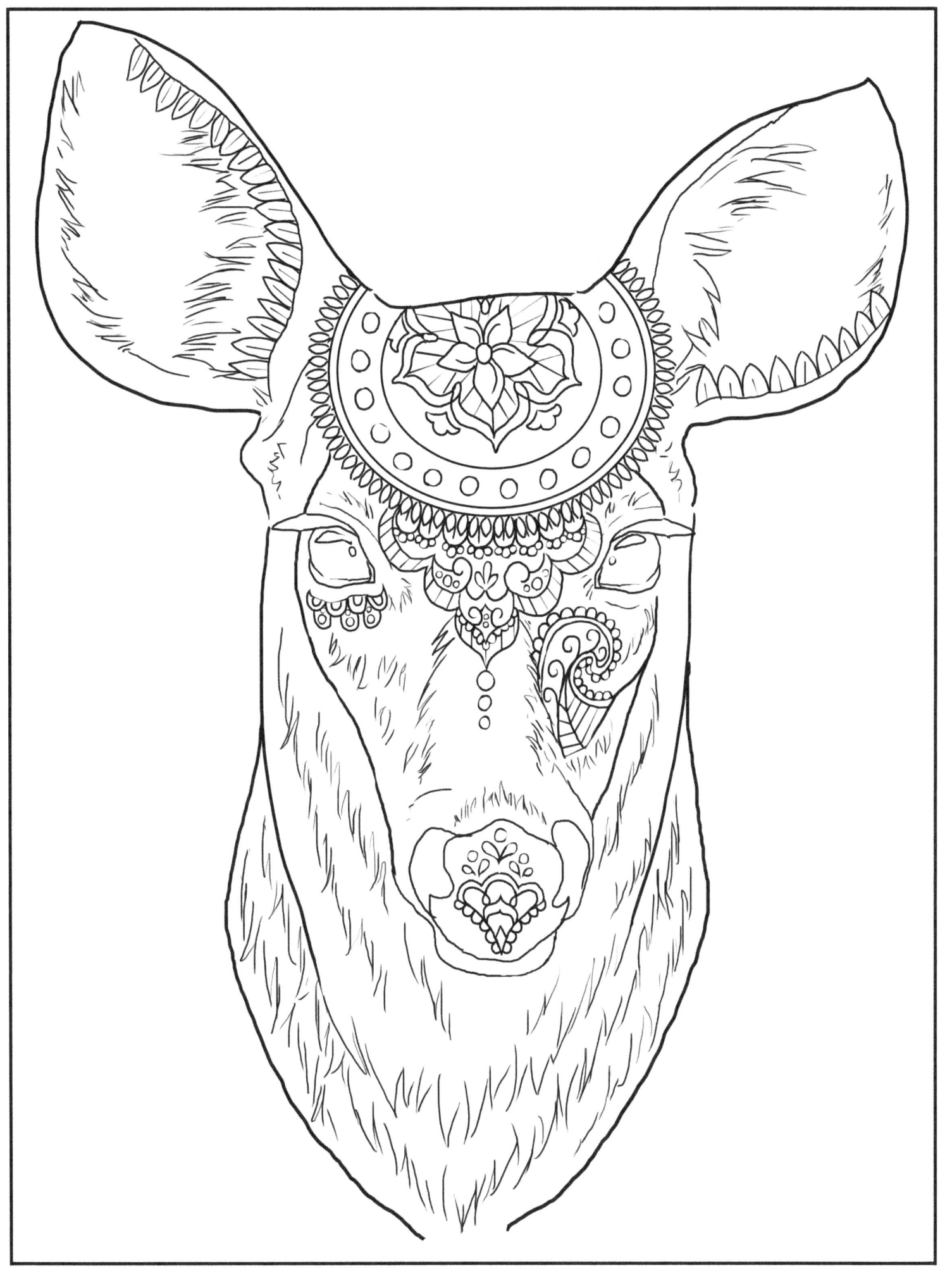

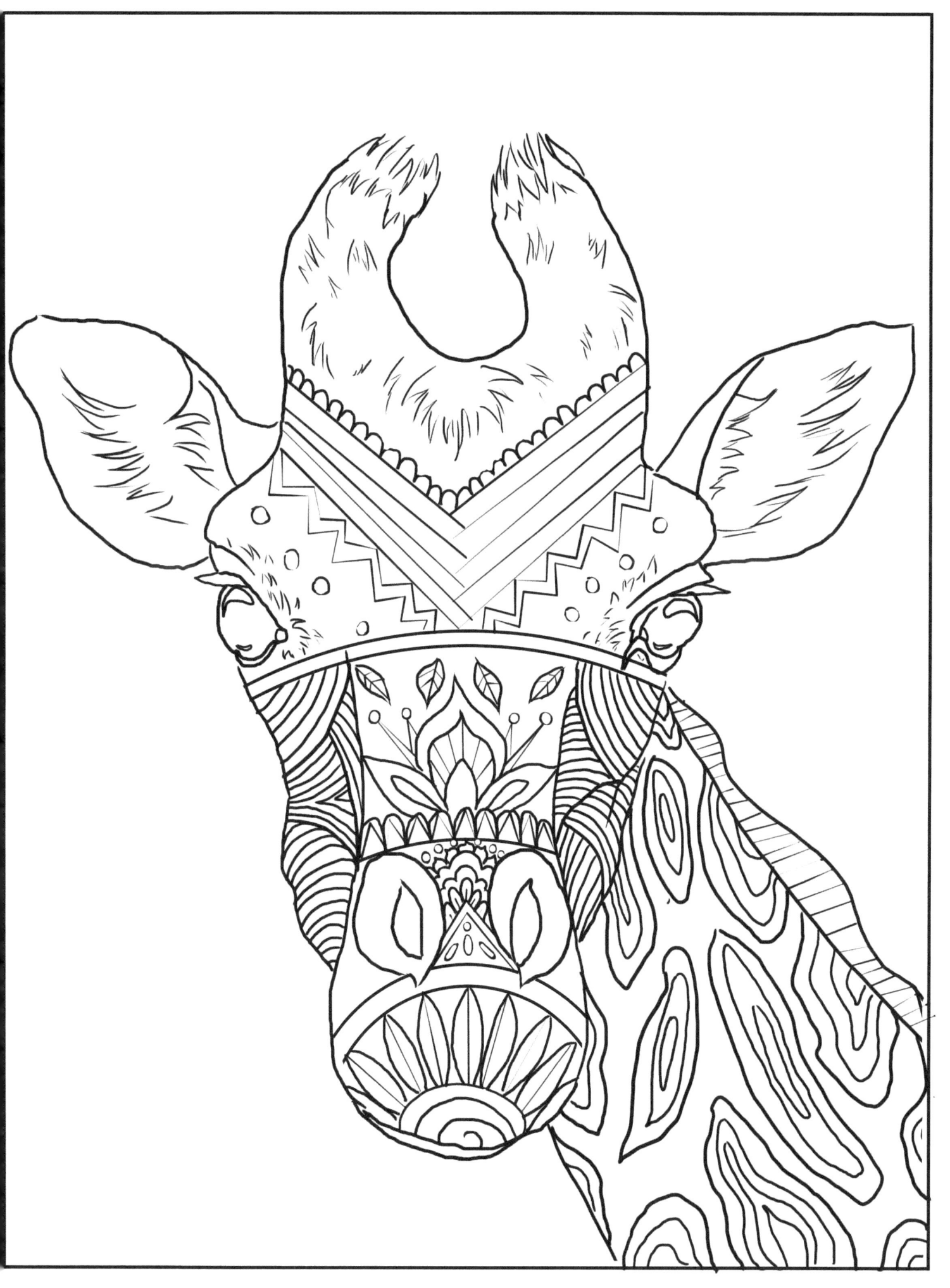

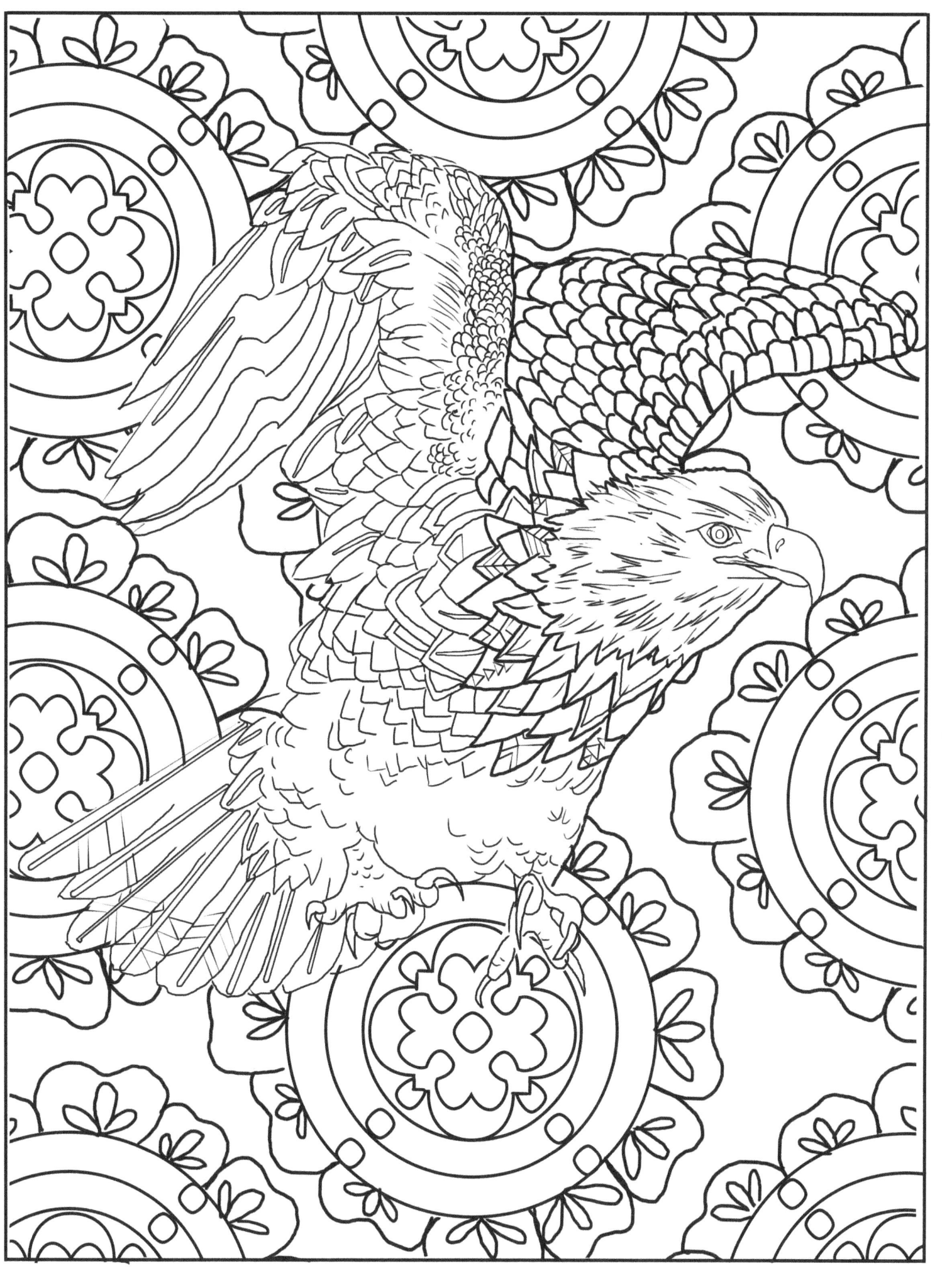

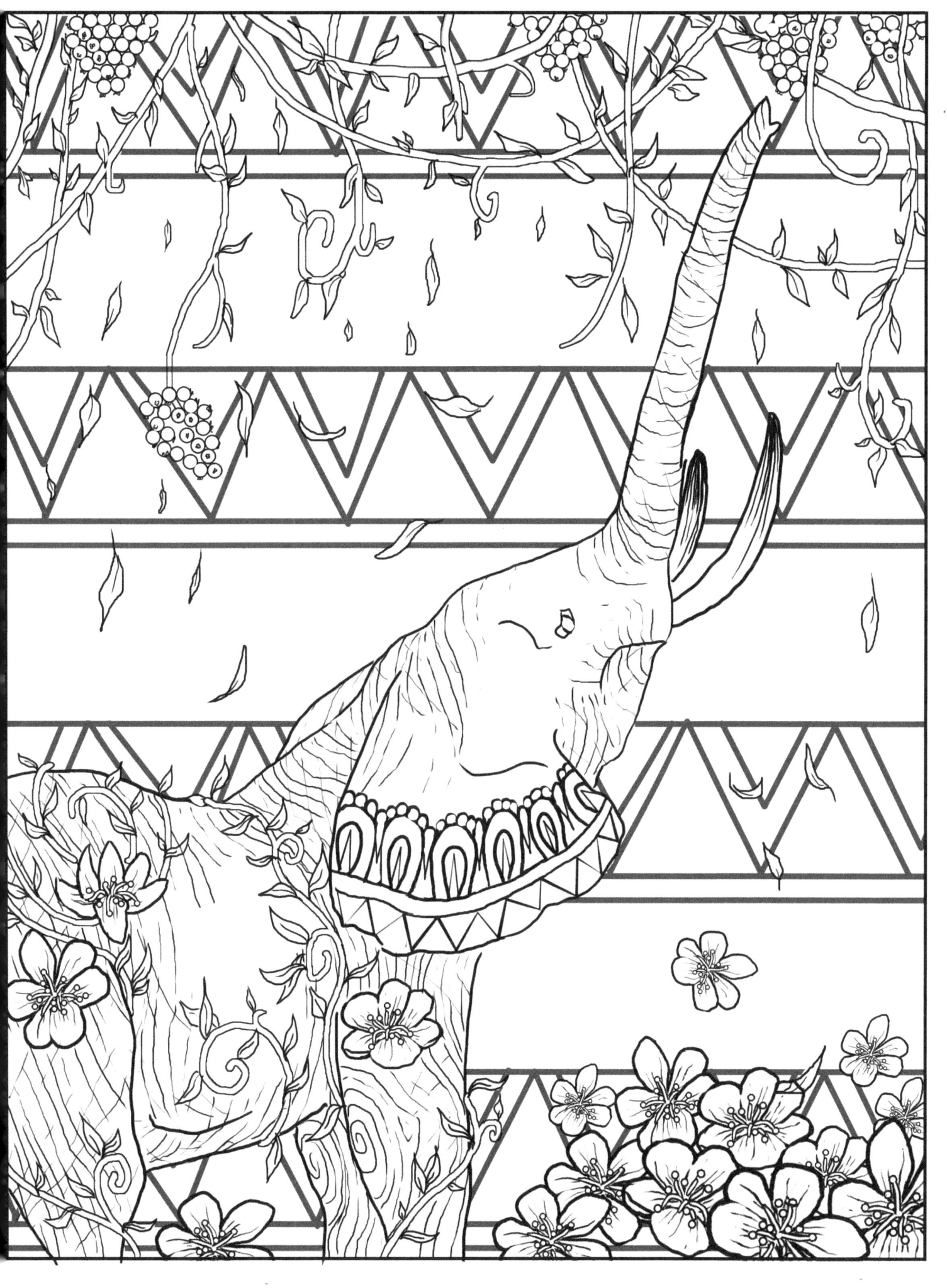

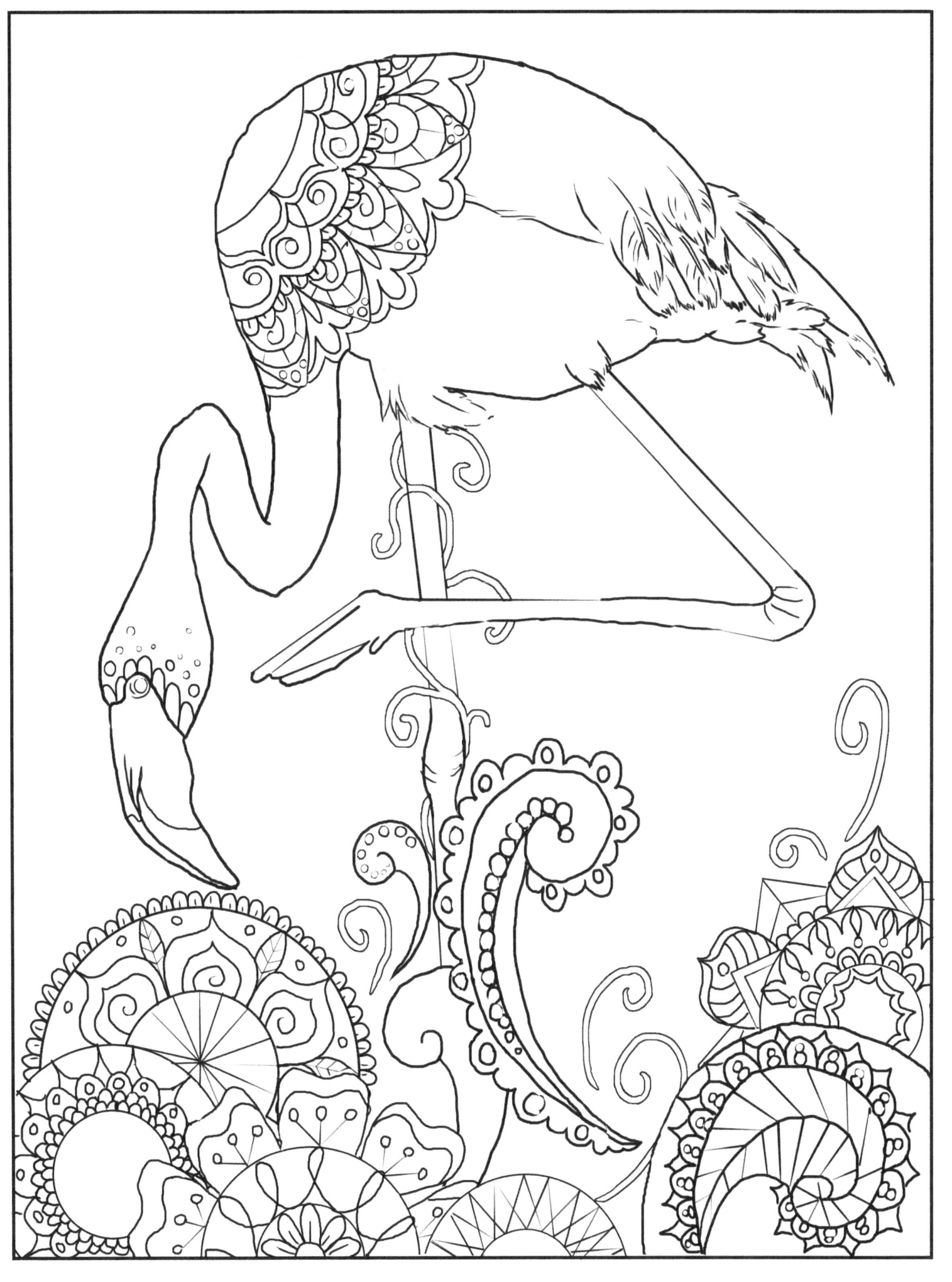

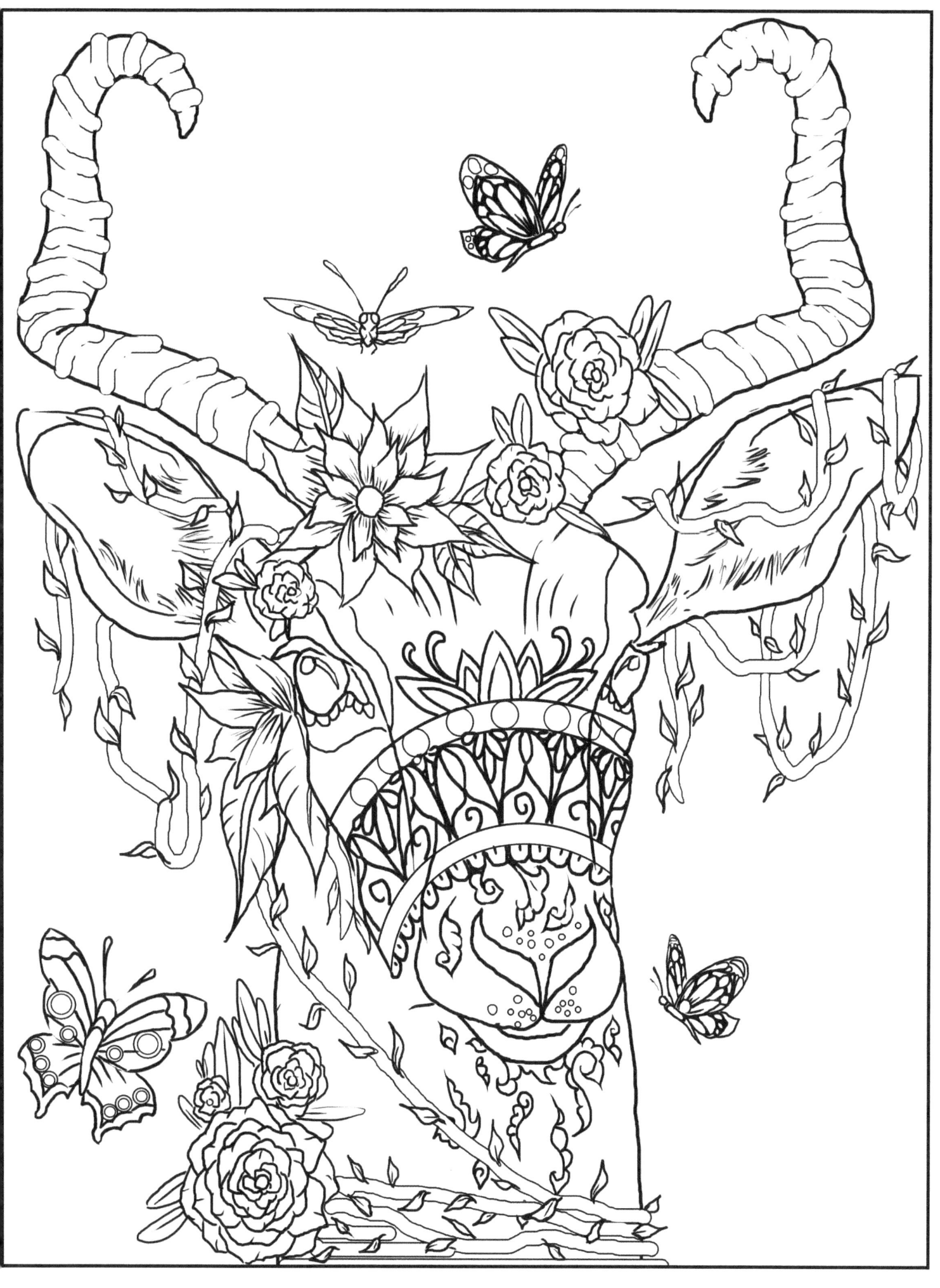

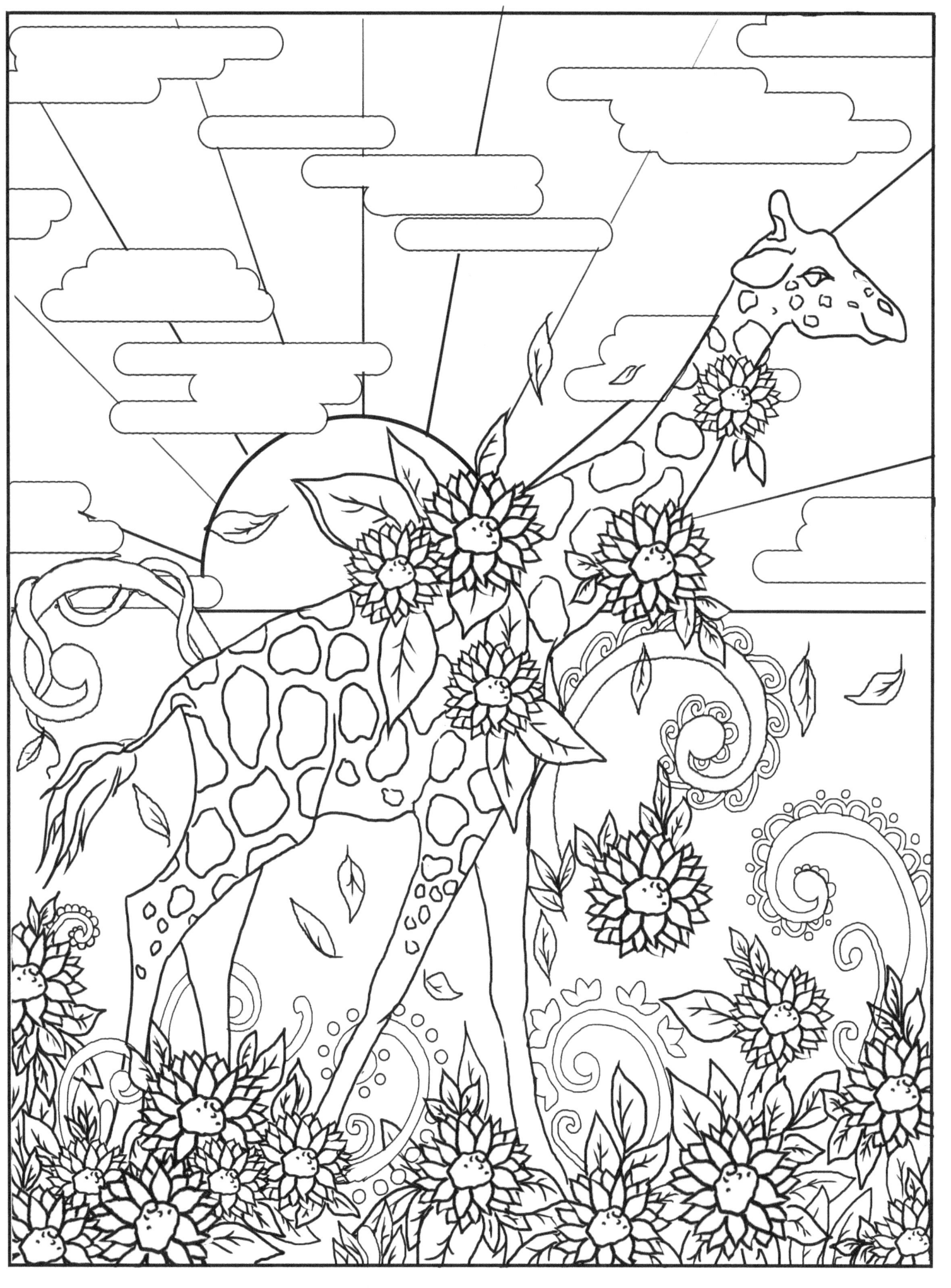

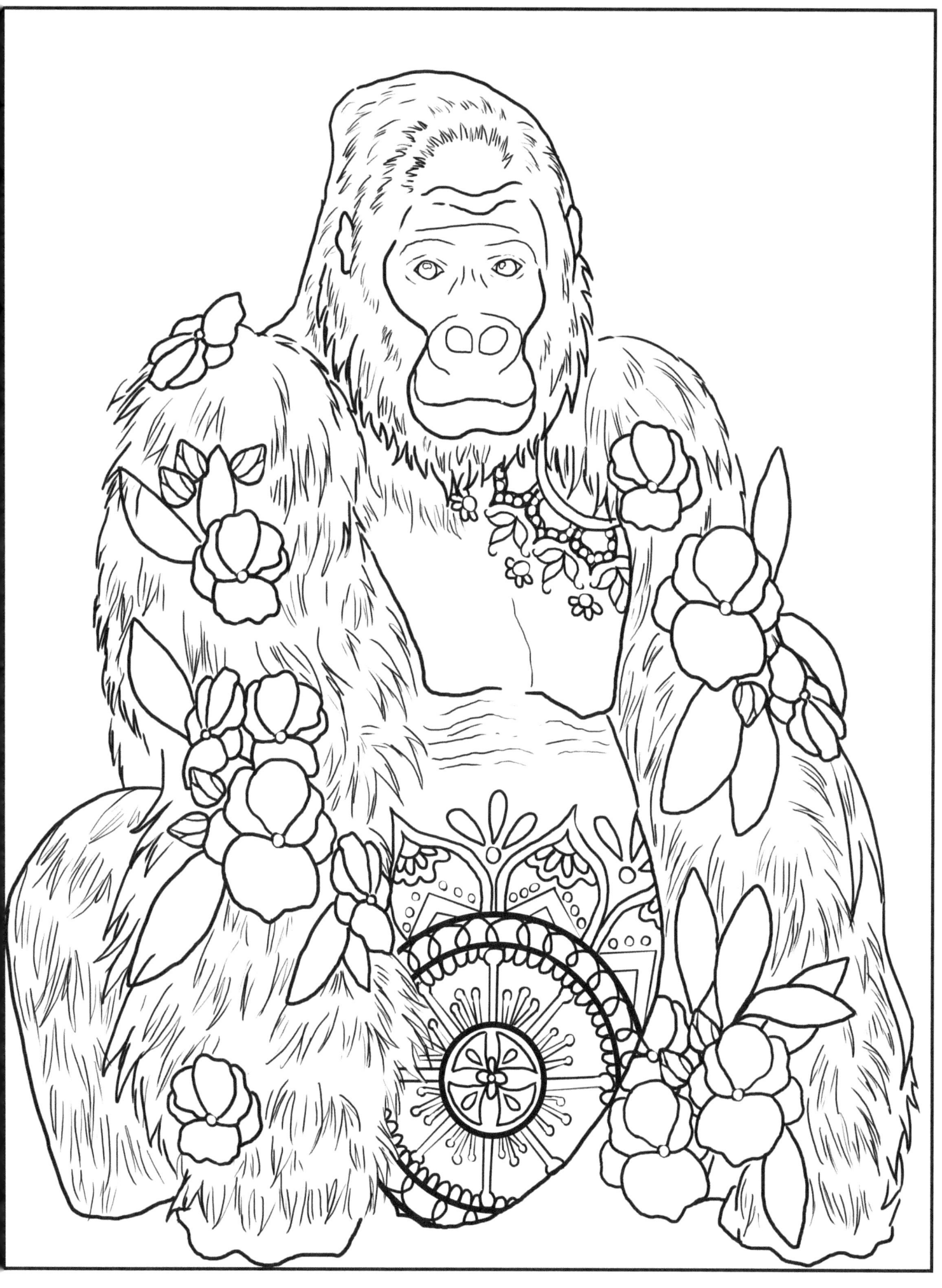

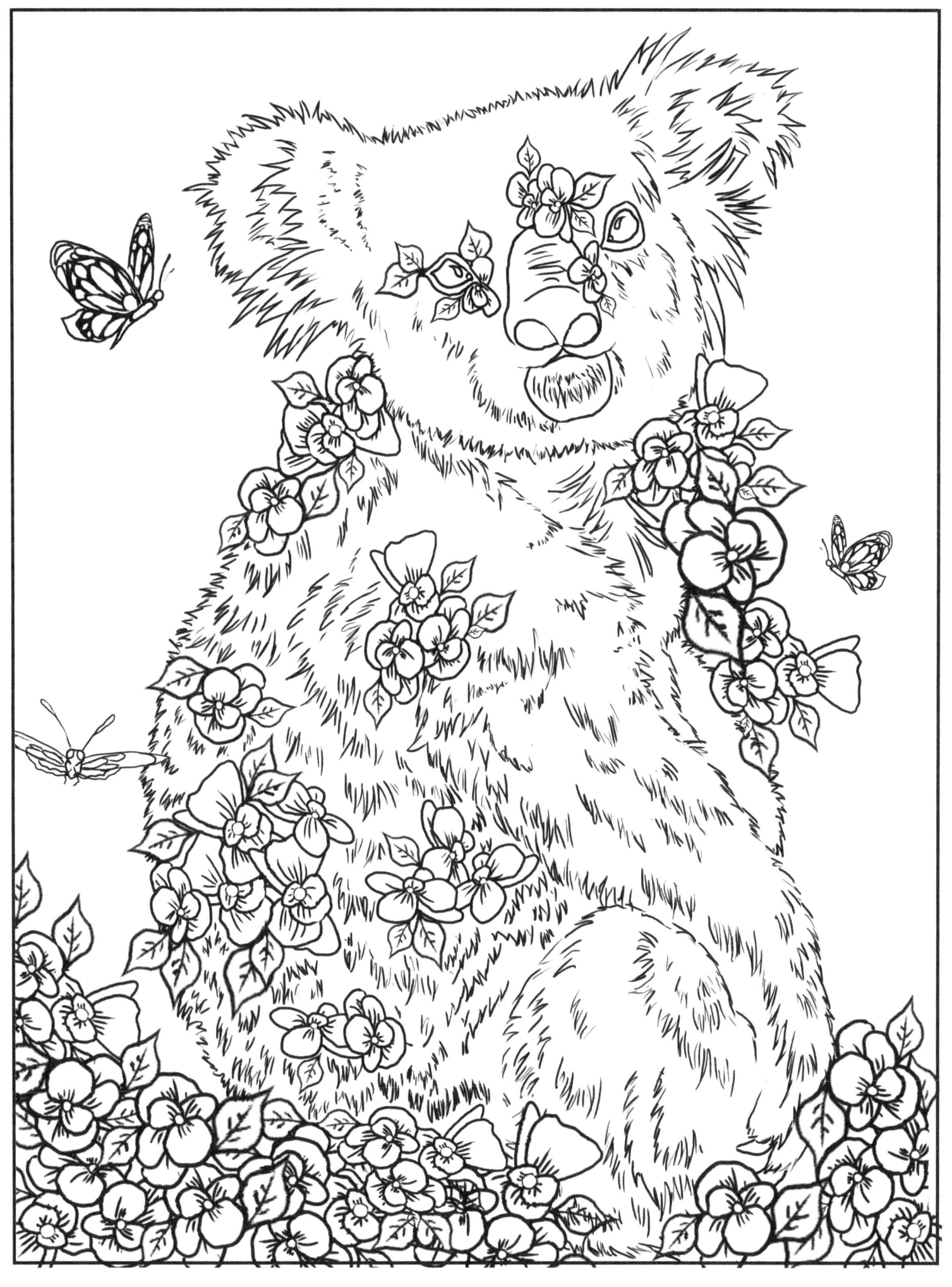

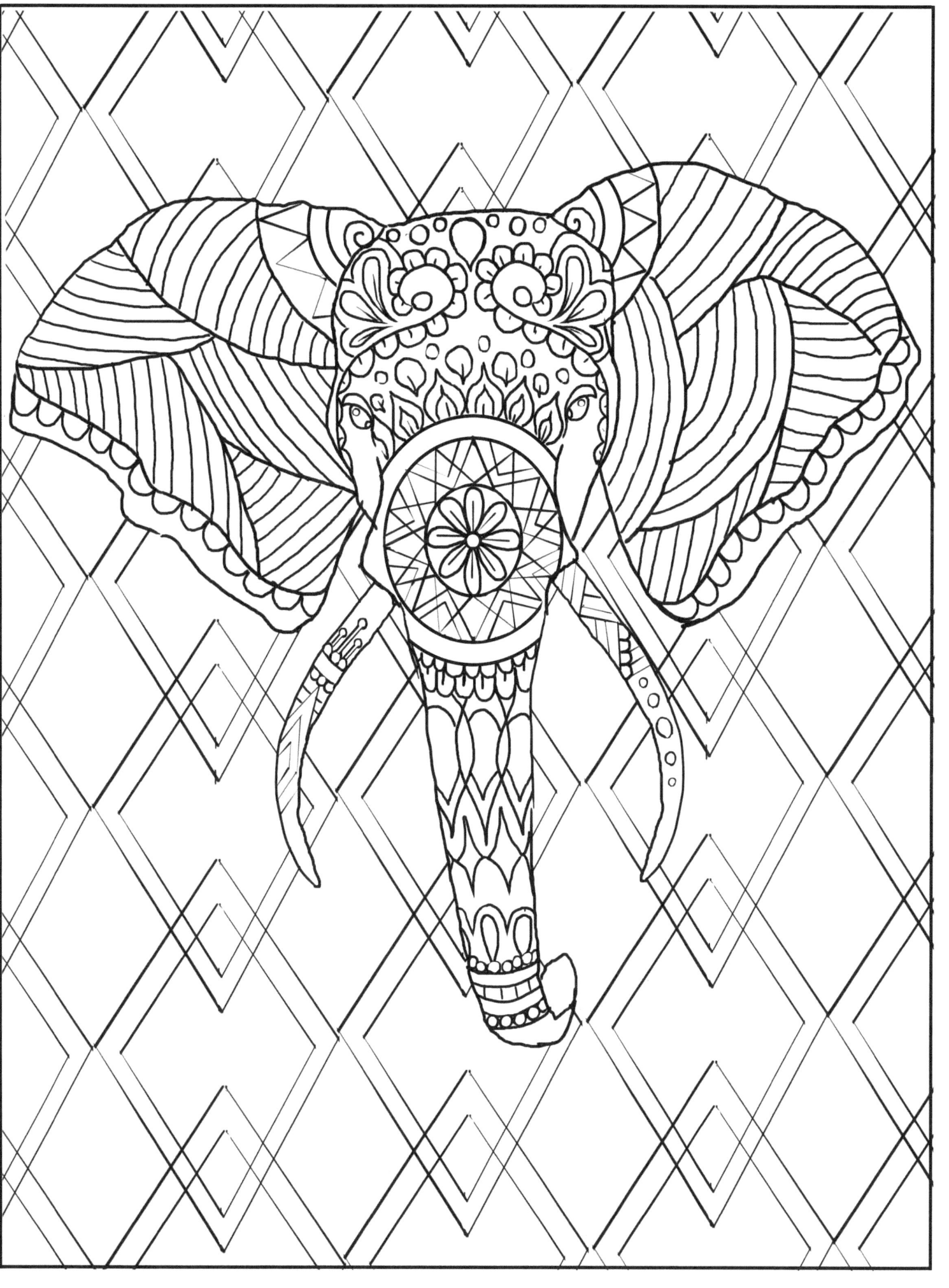

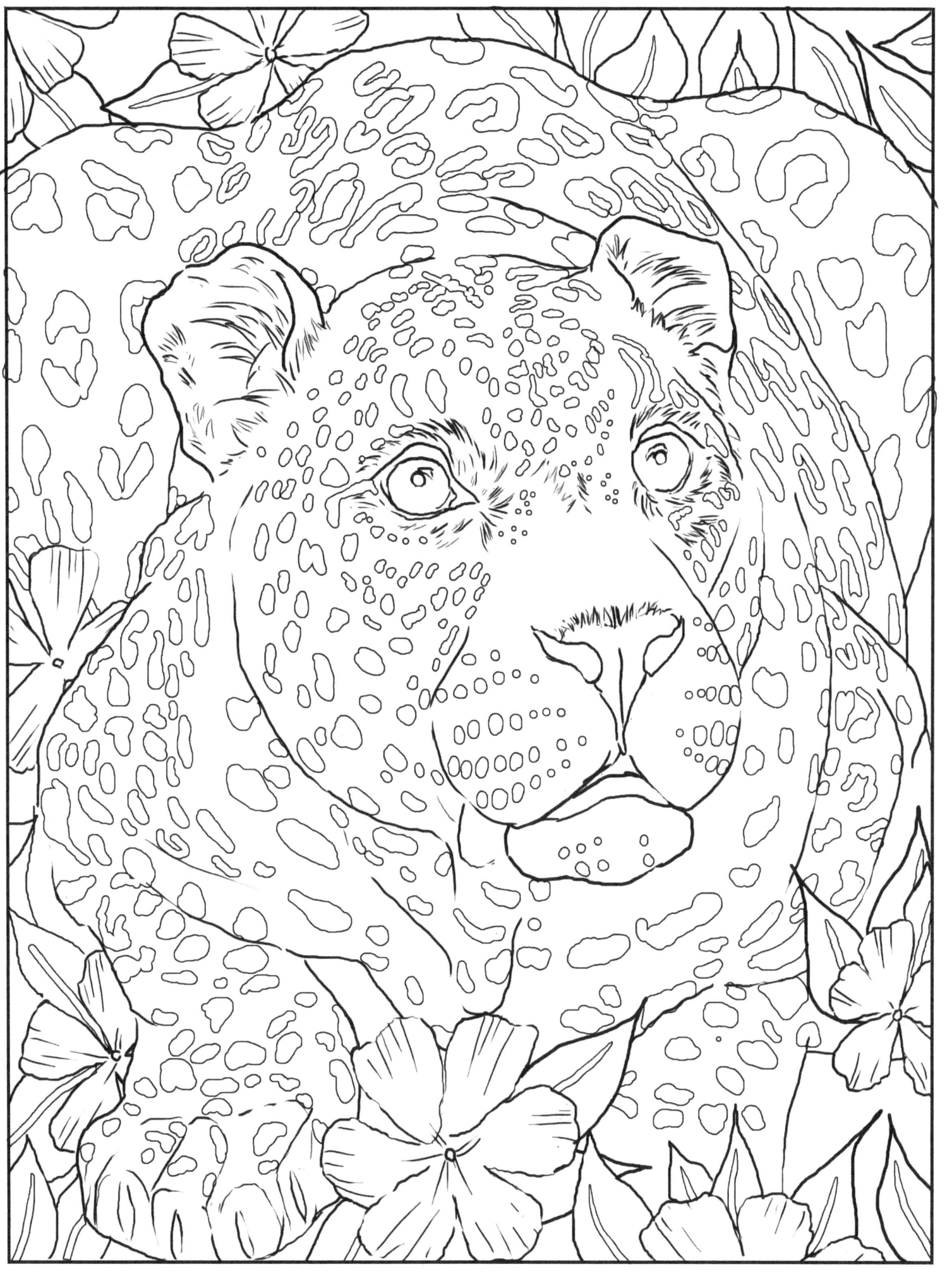

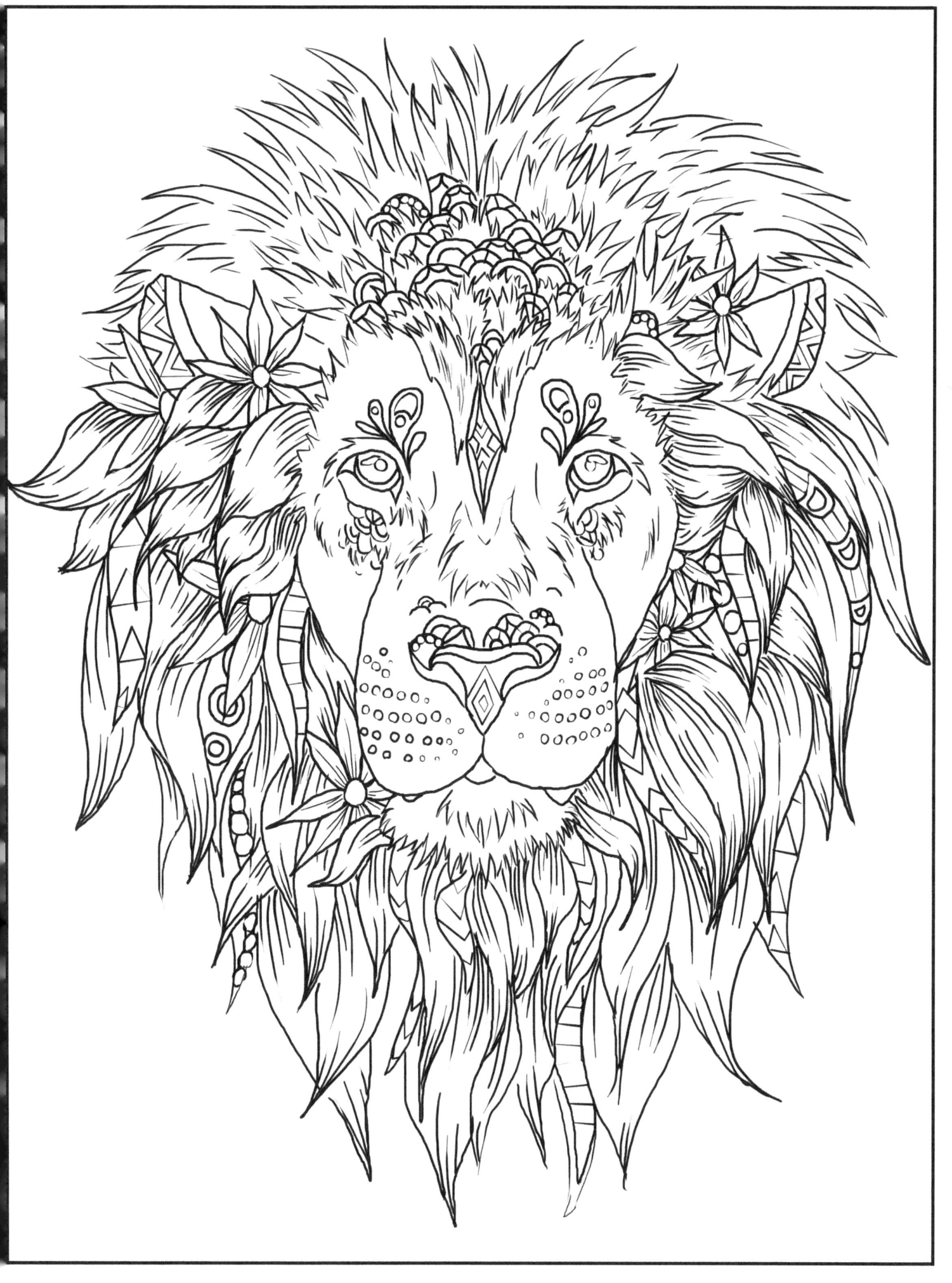

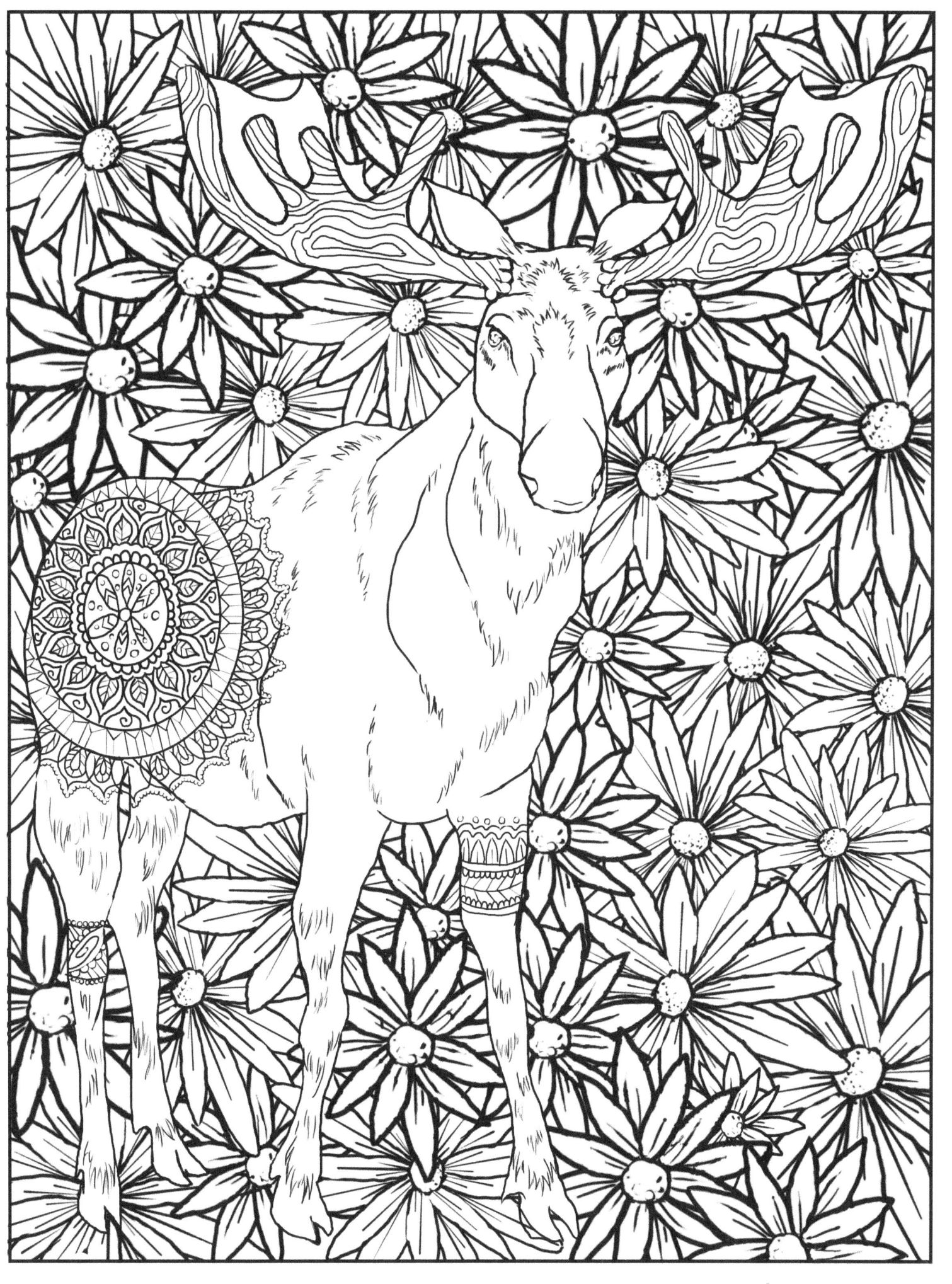

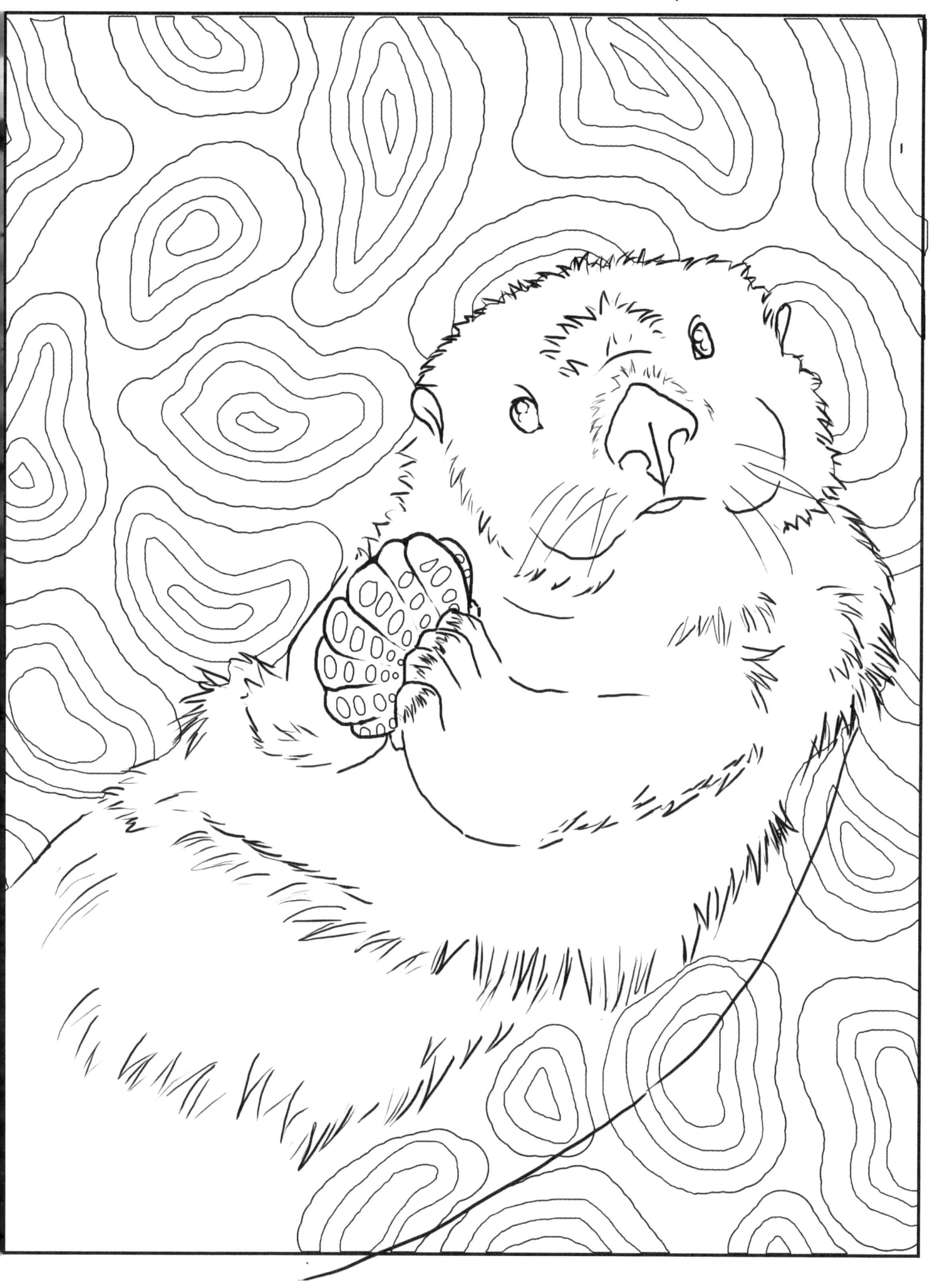

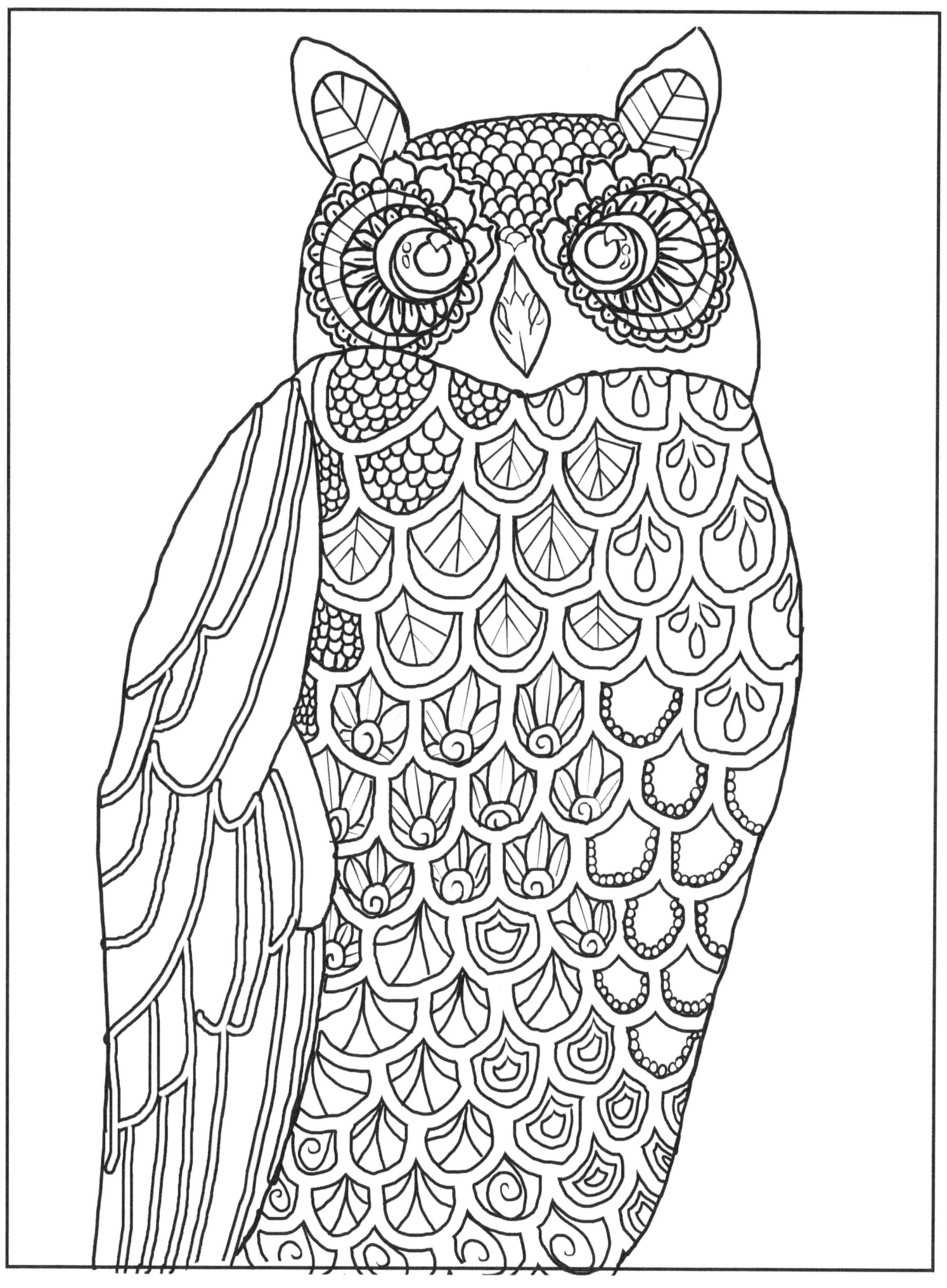

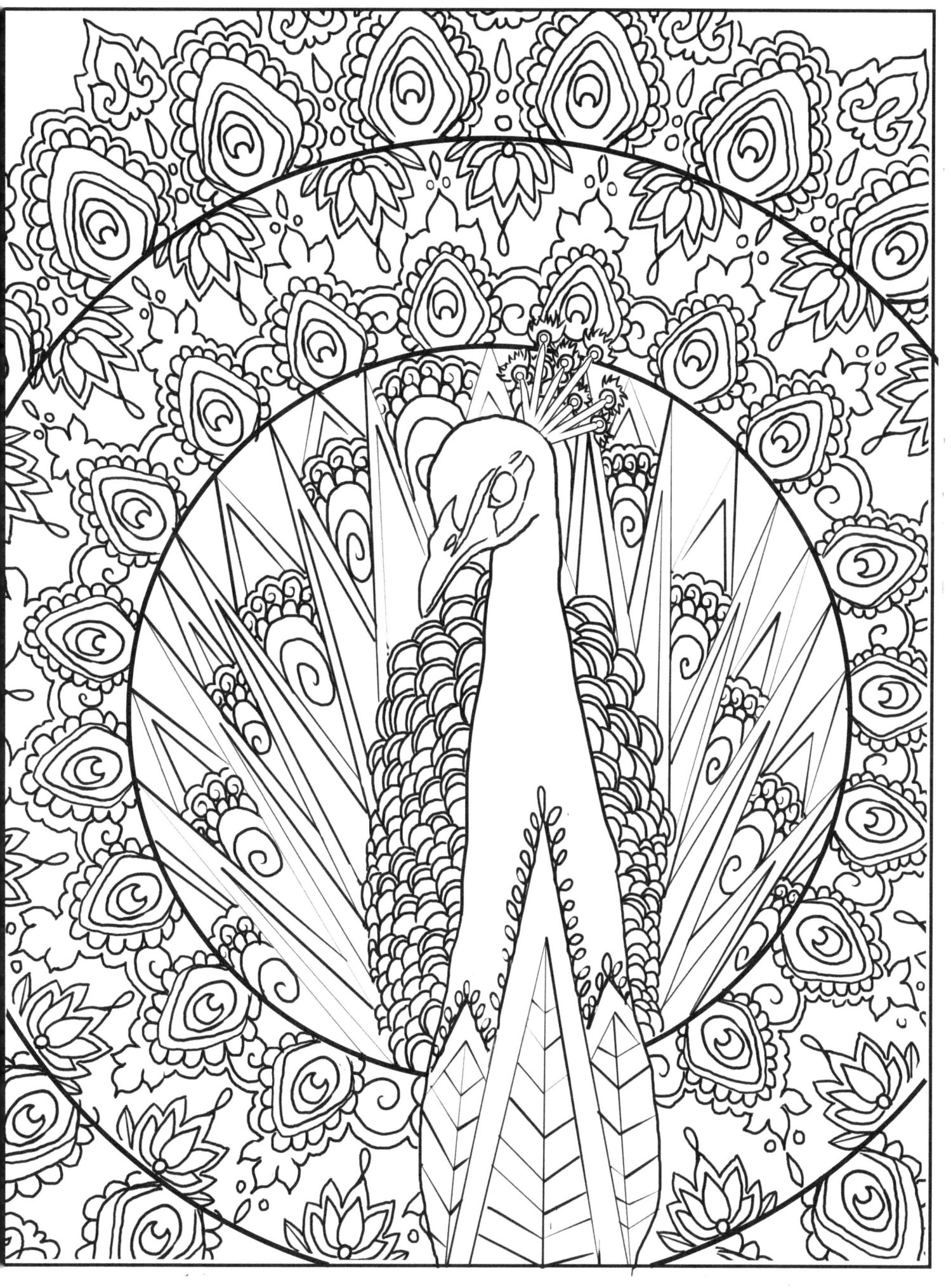

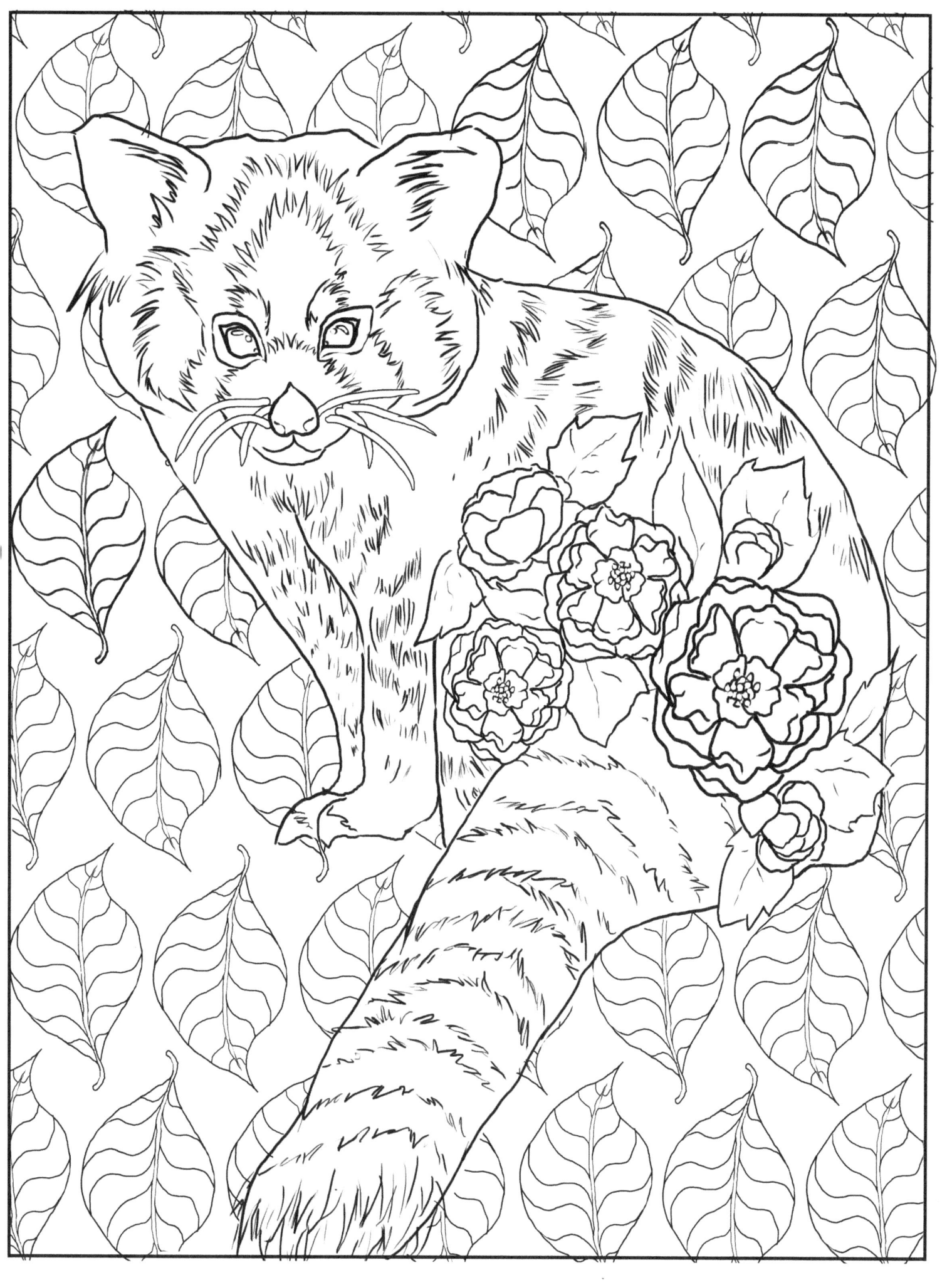

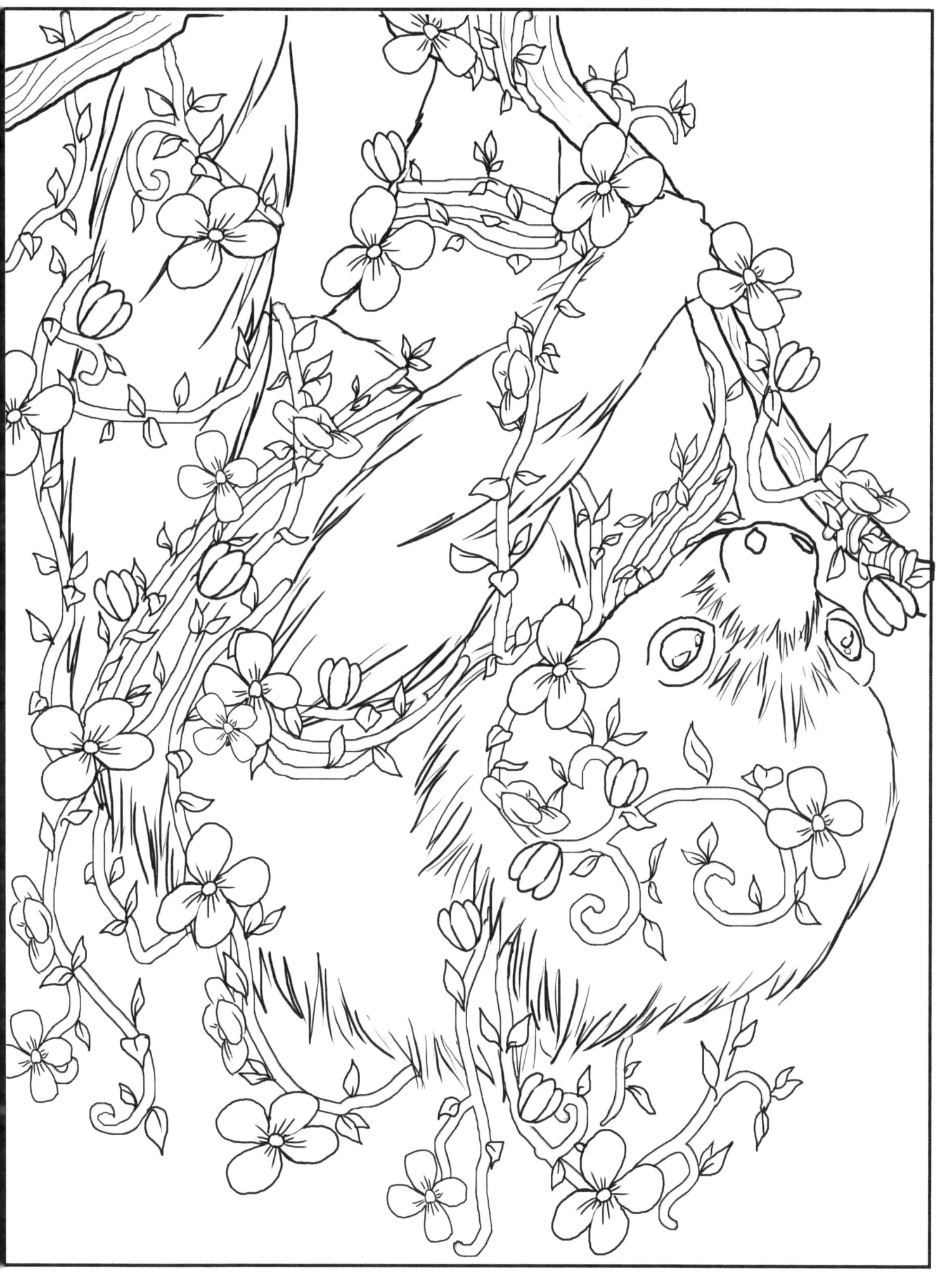

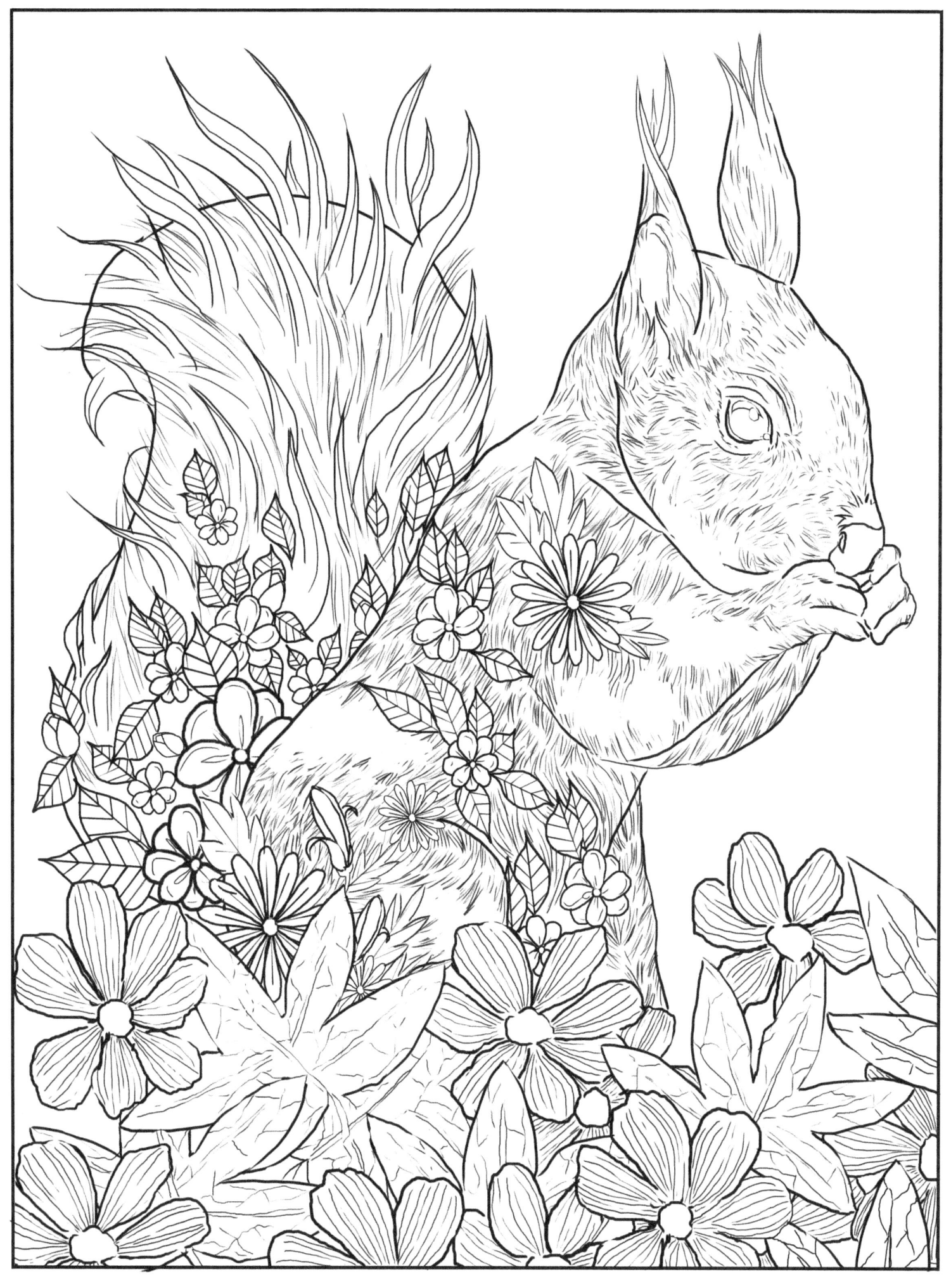

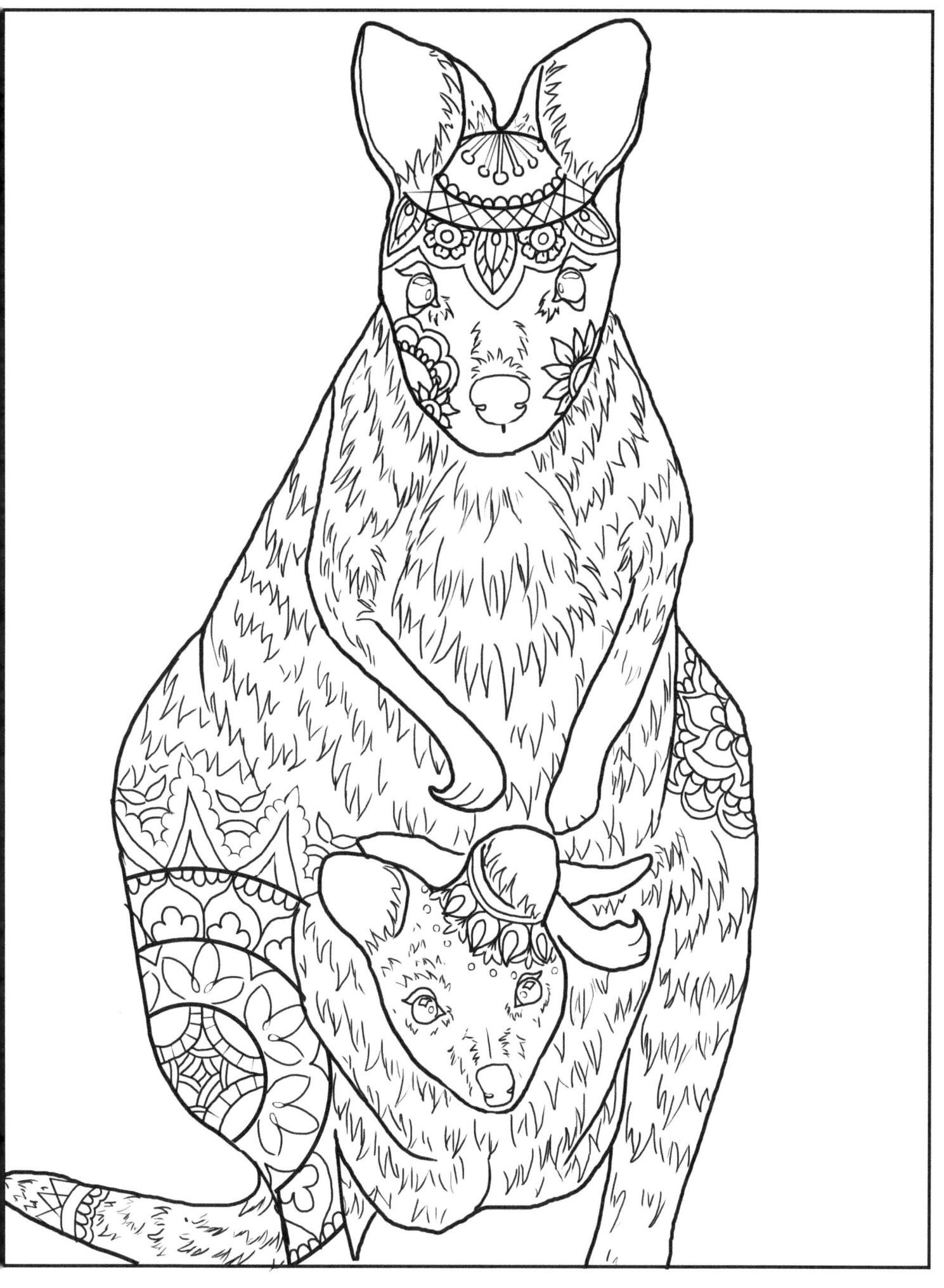

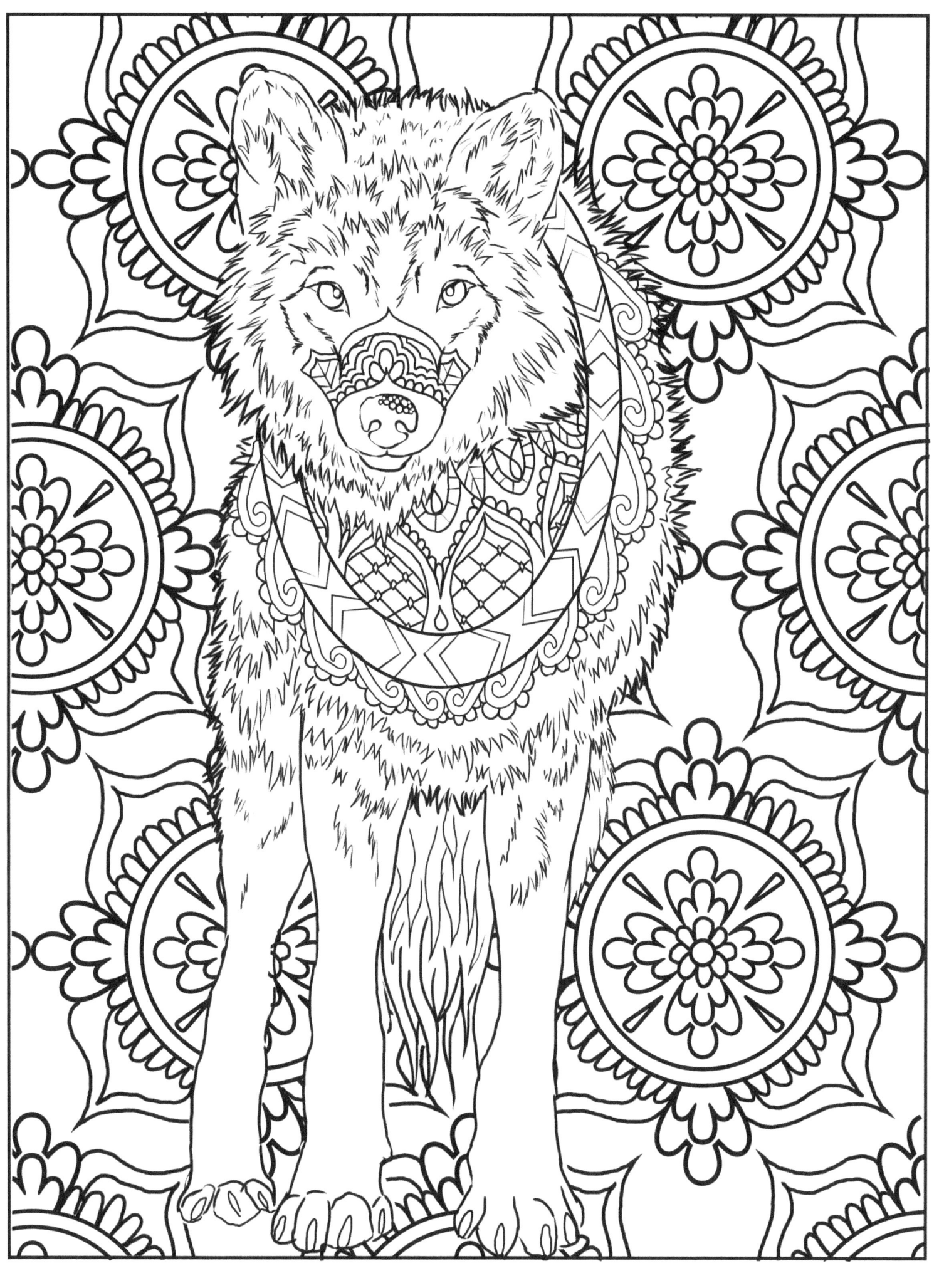

Hayley has other adult coloring books, such as **Colors of Australia** and **Colors of Halloween**.

Find them on Amazon!

www.ingramcontent.com/pod-product-compliance
Lightning Source LLC
Chambersburg PA
CBHW081306180526
45170CB00007B/2590